Everything You Need to Know About

THE DANGERS OF TATTOOING AND BODY PIERCING

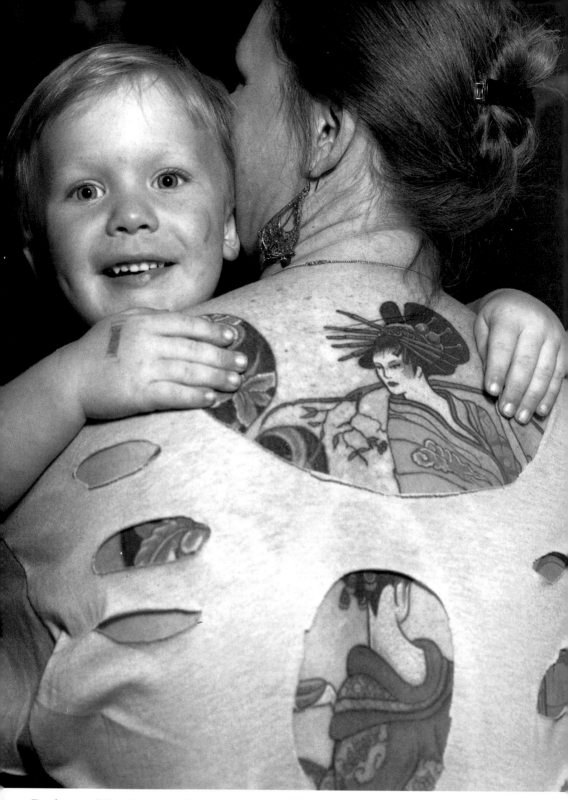

Body modifications such as tattoos and body piercings stay with you for life. Your choices today will send a message to your peers, your parents, and one day, your children.

Published in 1996, 1998 by The Rosen Publishing Group, Inc.
29 East 21st Street, New York, NY 10010

Revised Edition 1998

Library of Congress Cataloging-in-Publication Data

Reybold, Laura.
 Everything you need to know about the dangers of tattooing and body piercing / Laura Reybold.
 p. cm. — (The Need to know library)
 Includes bibliographical references and index.
 Summary: Presents a history of body piercing and tattooing before discussing the risks and consequences involved.
 ISBN 0-8239-2742-3
 1. Body piercing—Health aspects—Juvenile literature.
 2. Tattooing—Health aspects—Juvenile literature. [1. Body piercing. 2. Tattooing.] I. Title II. Series
 RD119.5.N82R48 1998
 617.9′5—dc20
 95-20227
 CIP
 AC

Manufactured in the United States of America

• THE NEED TO KNOW LIBRARY •

Everything You Need to Know About

THE DANGERS OF TATTOOING AND BODY PIERCING

Laura Reybold

THE ROSEN PUBLISHING GROUP
NEW YORK, NY

Contents

Introduction

*L*ately Sabrina and Helen had been considering getting their noses pierced. They just couldn't decide if it was a good idea. "I think I would look really great with a pierced nose," Helen said, "and guys seem to like it."

"Well, if you really want to, we could do it now," suggested Sabrina, excitedly. "We'll just make a tiny hole in your nose with a needle. We'll use ice to numb the pain. It won't even hurt."

Helen agreed and Sabrina went to find a sewing kit. She picked out a thin needle and got some ice cubes from the freezer. After rubbing ice over Helen's nose, Sabrina pinched one nostril and started to push the needle through it.

The needle was only halfway through Helen's nose when she started screaming for Sabrina to stop. Sabrina didn't want to hurt her, but she had to continue.

Although a body piercing such as a new nose ring or earring may seem really appealing, you should know all of the risks and possible consequences of following the latest fad.

Some people mistakenly believe that they can do a piercing at home, not realizing the high rate of infection and failure for these types of piercings.

"Okay, we're done," said Sabrina as she pushed the needle all the way through, despite Helen's obvious pain. "I'm sorry if it hurt." She slid a hoop earring through the hole.

Helen stared at her pierced nose in a mirror. The area around the piercing was red and it hurt a lot. But she liked the way it looked and figured the pain would go away.

The next morning, Helen's nose was really irritated. By nighttime, the piercing was crusty and a yellow liquid was oozing out. By the third day, it hurt so much that Helen took out the earring and decided to call a doctor. He told her that she would have to take antibiotics for the infection and come in for a visit.

Tattoos and body piercings have become one of today's most visible fashion trends. You see them on MTV, in magazine ads, on your favorite actors and musicians, and on your friends and classmates. Not so long ago, tattoos and body piercings were primarily associated with people on the fringes of society, such as circus sideshow performers, ex-convicts, and bikers. However, they are now becoming a part of mainstream culture, with popular stars such as Drew Barrymore, Johnny Depp, Dennis Rodman, Michael Jordan, and Madonna flaunting their body decorations.

Since ancient times, people have decorated their bodies and faces with tattoos and piercings in many different ways, depending upon their culture, the times they live in, and their individual beliefs. Tattoos and body piercings may be performed for spiritual or religious reasons; to mark an important stage, event, or person in one's life; to show one's social status; to create romantic attraction; or to be different from the mainstream. Today, many people are drawn to body art simply because it is a fashion trend.

Are you considering getting a tattoo or a piercing? If so, you need to think seriously about your decision. Tattoos and piercings can leave permanent marks on your body. While fashion trends come and go, your tattoo or piercing may be with you forever.

Also, getting a tattoo or body piercing poses serious health risks. Both procedures puncture your skin, leaving your body vulnerable to infections and diseases. You can reduce the risk of infection and disease by

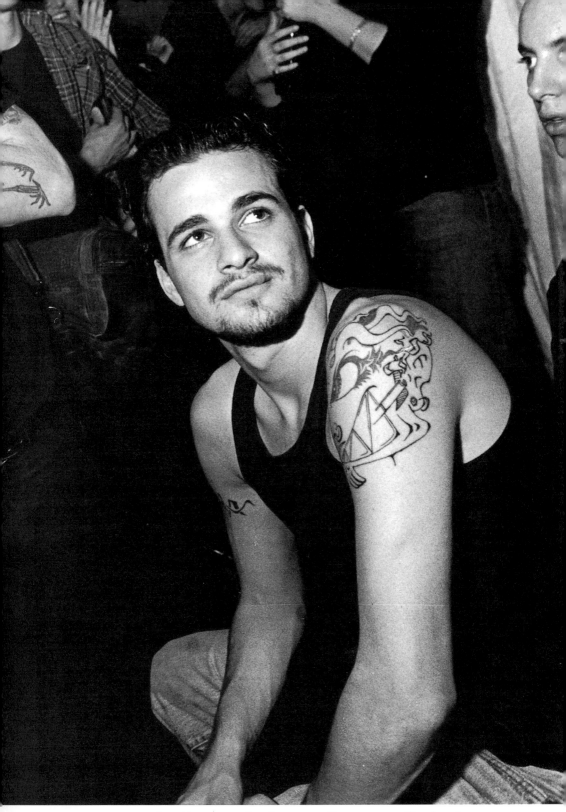

Tattoos permanently affect your body, even if you can afford to have them removed.

having a tattoo or piercing performed by a professional in a sanitary environment and by maintaining proper hygiene while the site heals. However, any tattoo or piercing can cause physical discomfort or result in infection, even if you take proper care of it.

This book will alert you to the risks and consequences of getting a tattoo or piercing. You will learn how tattoos and piercings should be performed and the safety precautions you should take to minimize health risks. It also will discuss removal treatments for those who want to get rid of their tattoos or piercings. Finally it will present various ways to help you feel part of the body art trend without permanently affecting your body.

Tattoos and piercings can be a lifetime commitment. It is important to know the facts and risks involved. Making a safe and informed decision will satisfy you both now and in the future.

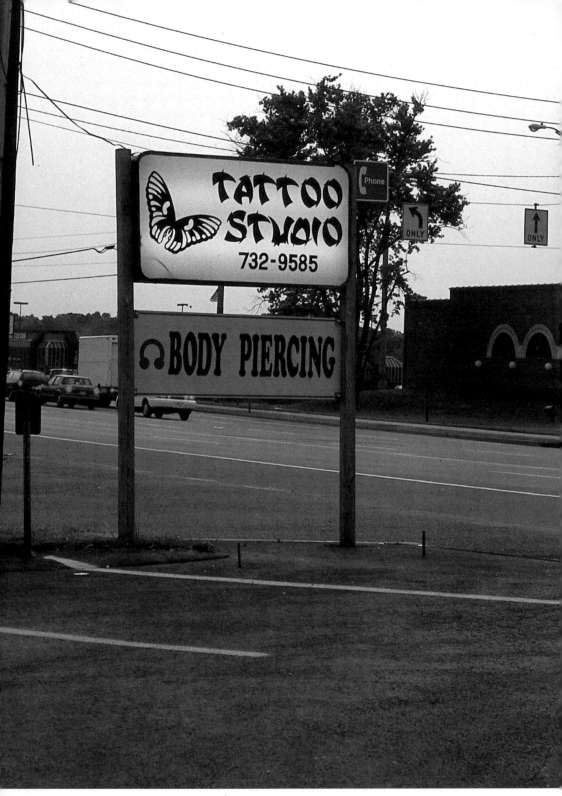

Tattoo parlors can be found throughout the United States, both in rural communities and in large cities, despite the fact that they are sometimes outlawed.

Chapter 1

The History and Process of Tattooing

Tattooing is a permanent method of decorating the skin. It is performed by inserting colored inks or dyes under the surface of the skin with a needle or other sharp instrument.

The word *tattoo* comes from the Tahitian *tatu,* "to mark something." No one knows exactly where, when, or why the practice of tattooing began. However, there is evidence that the ancient Egyptians practiced tattooing between the years 4000 and 2000 BC.

Tattoos have been seen in hundreds of cultures around the world. According to Amy Krakow in her chronicle called *The Total Tattoo Book,* "tattooing has had well-defined roles: marking a rite of passage at a stage of life, calling the spirits, proudly, defiantly or sneakily showing who you are via body art. That's pretty much how the tattoo tradition evolved, and it's pretty much the way it remains."

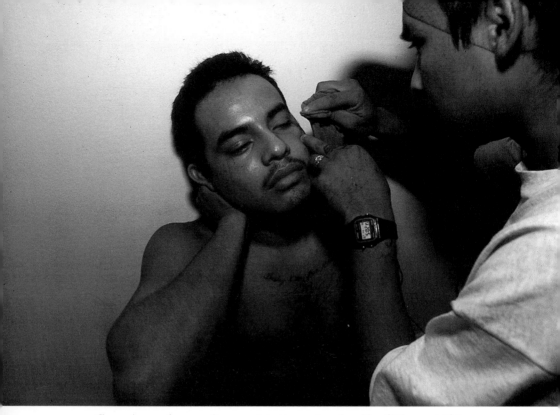

Gang members often get tattoos to signify different things such as membership, or, in this case, to show a completion of jail time.

The social meaning of tattoos has varied from society to society.

In 1994, Russian archeologists discovered the mummified body of a woman who, they believe, lived 2,000 years ago. The intricate blue tattoos on the woman's left arm, along with her rich burial trove, led the archeologists to conclude that she was a princess and priestess in ancient Siberia.

In New Zealand, the Maori and Tamoko used tattoos to indicate rank in society. The Maori developed a style of facial tattooing known as *Moko* for its warrior class. The Ainu of Western Asia also used tattoos to show social status. In

Borneo women tattoo artists were marked with hand and finger tattoos to show their position as weavers in their culture.

Burmese tattooing has been associated with religion for thousands of years. Tattooing among indigenous North American groups including the Arapaho, Mohave, Cree, and Inuit (Eskimo) is rooted in the spiritual realm as well. Tattoos of spirit birds were common in all of these societies. Each of these groups had a myth about a great flood, and it is believed that the chin tattoos they used were meant to represent the floodline of mythology.

It was an ancient Japanese tradition to tattoo convicted criminals, but over time the practice underwent an amazing transformation. Around 1700 the role of the Japanese tattoo was changed from one of social marking and religious symbol to one of artistic beauty. At that time, only members of the royal family were legally permitted to wear embroidered clothing. People who were not members of the royal family who wanted to beautify themselves began having large, colorful designs tattooed on their torsos and upper arms. In this way, they could decorate themselves without breaking the law. Some of these tattoos were so large that it took years to complete them.

At the same time, tattoos were gaining popularity in England among the wealthy. In 1691 the English explorer William Dampier brought a

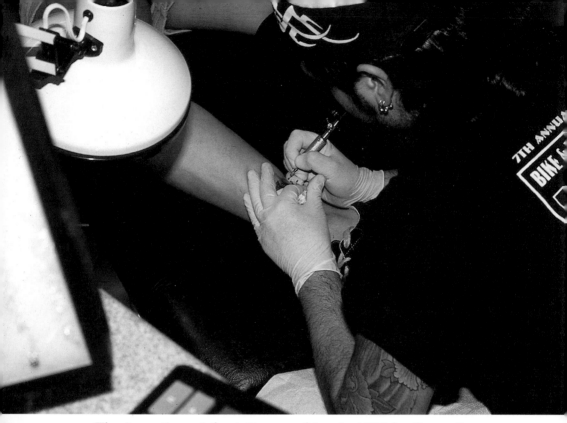

The invention of the tattoo machine in 1891 by Samuel O'Reilly made it possible for nearly anyone to get a tattoo.

tattooed man from the South Pacific back with him to England. Known as the Painted Prince, he was, unfortunately, placed on exhibit. Nearly 100 years later another explorer, Captain James Cook, returned to London with the Great Omai, a Polynesian man who was covered with tattoos. The Great Omai was such an attraction that the noble classes of England soon began getting small tattoos of their own.

The era of tattooing as an upper-class art form soon came to an end. This is because the invention of the electric tattoo machine made the fad affordable to virtually everyone.

Tattooing in the United States

The first electric tattoo machine was patented by Samuel O'Reilly in 1891. It was based on moving coils, a tube, and a needle bar. By 1897 tattooing had reached the United States, where tattooed people immediately became a circus sideshow attraction. Over the next fifty years the number of tattooed individuals in the United States rose steadily. Military men had tattoos representing the type or location of their service, young lovers declared their eternal love through tattoos, and devoted sons proudly displayed "Mom" on their arms. Tattoo artists expanded the selection of designs known as flash, displayed on the walls of their tattoo parlors. Flash was sold in sets that could be legally reproduced onto stencils and bodies. Flash is still sold in the same manner today.

In New York City in 1961, health officials blamed an outbreak of hepatitis B (a very contagious disease that affects the liver) on tattoo artists who allegedly used contaminated needles and pigments. City officials became very concerned about sanitation and hygiene within the tattoo industry. Because of this outbreak, tattooing was outlawed in New York City and in many other parts of the United States. Tattooing became a violation of the health code in many places. However, the hepatitis epidemic was never conclusively linked to tattooing. In 1997, the ban on tattooing in New York City was lifted.

Today in the United States, tattooing is against the law in some communities. In other places, it is restrict-

ed to persons at least 18 years of age.

Where tattooing is legal, however, there is little or no government regulation of tattoo artists and their facilities. This means that there may be unscrupulous or incompetent tattooists, called "scratchers," who do not follow important safety precautions when tattooing their clients. Tattooing opens your body to potential infection, disease, and scarring. For this reason, it's important to safeguard your health by knowing what to expect from the tattoo process.

How Is Tattooing Done?

A responsible tattoo artist first discusses the design and placement of the tattoo with his or her client and answers any questions the client may have. He or she should also be prepared to show the client the studio's facilities and sterilization equipment, if requested.

When the client is ready, the tattooist starts by making a stencil, or tracing, of the design. The design can be altered or redone if the client isn't satisfied with it. The stencil is then placed on the client's skin, where it leaves behind a replica of the design. The tattooist follows the outline with a device called an outliner, which uses needles to inject ink into the skin. There may be a lot of bleeding during this procedure. Next, the tattoo artist shades in and colors the design using a shader.

Most tattoo artists still use an electric machine based on the original by Samuel O'Reilly. Over the years, many changes and improvements have been made to O'Reilly's machine. When the tattoo is com-

plete, the tattoo artist should provide a pamphlet with instructions on how to care for the new tattoo.

An autoclave, which sterilizes equipment using steam pressure, is an essential part of any responsible tattoo studio. All needles and equipment must be properly sterilized in the autoclave. Immersing needles in boiling water or rubbing them with disinfectant will not kill all viruses or bacteria. If a tattooist does not adequately sterilize equipment, you risk contracting bacterial and viral infections. Hepatitis can be transmitted through the use of unsterilized needles, as can the herpes simplex virus, or even HIV (human immunodeficiency virus), the virus that causes AIDS (acquired immunodeficiency syndrome). A tattoo artist should also wear surgical gloves to ensure proper hygiene.

Thus far, there have been no medical reports of HIV infection from professional tattooing. Yet doctors warn that transmission of the HIV virus through unsafe tattooing practices is possible and that people should be careful to protect themselves.

Several self-regulating associations of tattoo artists strive to make tattooing safe. One such group is the Alliance of Professional Tattooists, Inc. (APT). APT holds lectures to update tattoo artists on information about sterilization techniques and distributes guidelines for tattooists regarding disease control. If you decide to get a tattoo, use a studio that belongs to APT or to the National Tattoo Association (NTA).

In many cultures throughout the world, body piercings have a spiritual or cultural significance. In the West, however, such piercings are a fad driven by popular culture.

Chapter 2

The History and Process of Body Piercing

The history of body piercing is not as well documented as that of tattooing. It is known, however, that it has been practiced throughout the world for thousands of years.

Traditionally, many piercings were performed for religious or spiritual reasons. For instance, many African peoples believe that demon spirits will fly up a person's nostrils and cause illness. A ring worn in the nose wards off these evil demons. A similar belief pervaded Europe during the Middle Ages. There demons were thought to enter the body through the left ear, and it soon became common for men to wear earrings.

Piercings have also been used as a means of displaying social rank or status. In ancient Rome, slaves who were in the service of the emperor could be recognized by distinguishing piercings. Piercings are often used to

celebrate a rite of passage such as a boy's passage into manhood or a girl's passage into womanhood. Many Mursi women in Ethiopia's Lower Omo River Valley have their lower lip pierced and a lip plate inserted when they come of age.

Finally, a person may choose to be pierced merely for decorative reasons. The majority of the piercings performed in the United States today are for decoration. Ear piercings have been a popular fashion among women in the U.S. since the turn of the century. In the 1980s it became common for women and men to have multiple piercings in their ears. The 1990s have brought a whole new array of body piercings. Nose, eyebrow, lip, tongue, cheek, belly button or navel, and septum (the part of the nose that separates the two nostrils) piercings all have become a new fashion statement.

Like all fashion statements, piercings will probably fall out of fashion eventually. But, unlike an out-of-style pair of jeans, your body piercing can't be stored away in the attic. It's a part of your body.

Piercings are believed by some people to improve one's sex appeal. But as we've seen, different societies, and individuals within societies, have their own view as to what is sexy. Your own views, too, may change. What if your future boyfriend, girlfriend, husband, or wife doesn't think your piercing is sexy? Since piercing can have permanent effects, it may be worth considering alternatives, such as body jewelry for

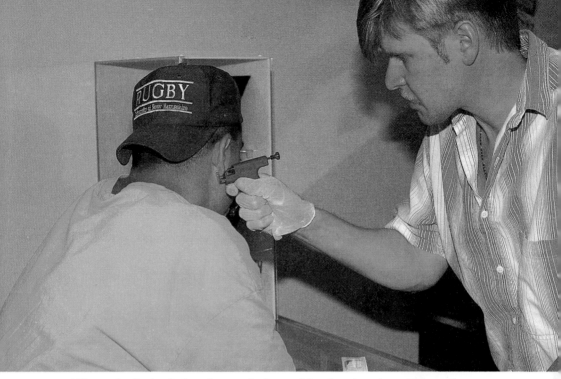

There is little federal regulation of body piercing. Virtually anyone can claim to be an expert, which is why it is important to go to a true professional if you do decide to get a piercing.

your nose, navel, or ears that only appears to be pierced.

Little government regulation applies to body piercing. Few local governments actively monitor piercing establishments. For that reason, it is essential that you guard your own health.

The Process of Piercing

All piercings should be performed by a professional—never by someone who is not specially trained. Important nerve tissue, muscle tissue, and organs can suffer permanent injury in an improperly performed piercing.

23

It is essential that the equipment be sterilized. Even disposable needles should be sterilized. It is possible to contract HIV, hepatitis B, tuberculosis, syphilis, and other blood-borne diseases from an unsterilized needle. Contracting any of these diseases is dangerous. But the risk of contracting HIV from an unsterilized needle is the greatest risk, because it causes AIDS, which is nearly always fatal. There is no known cure for AIDS. For that reason, an autoclave should be standard equipment in every piercing studio. Never use a studio without one.

Piercings of various body parts are performed differently. Piercing guns are appropriate only for ear piercings. Most others are performed with a specially designed needle. Topical anesthesia is sometimes used, depending on the location of the piercing, but usually there is nothing to numb the pain.

Some piercings, including navel piercings, are performed with the use of a surgical clamp. The piercer cleans the area with a disinfectant, such as rubbing alcohol, and draws two dots on the area to be pierced. One dot marks the spot where the needle will enter the body, the other where the needle will exit. The area to be pierced is then clamped, pulling the skin to be pierced away from the rest of the body. This eliminates the possibility of accidentally piercing vital body tissue. Nose piercings, like most facial piercings, are performed with a needle. Again, dots are made at the points where the needle should enter and exit. The piercer then pushes the needle through the flesh.

Specially designed jewelry is inserted in all piercings. Earrings are not suitable for most piercings other than those in the ears. Doug Mally and Jim Ward, who are credited with being the popularizers of modern piercing, designed a whole line of body jewelry in the 1970s. Ring-shaped jewelry is inserted in navel piercings. Other piercings can have either ring- or stud-type jewelry inserted. Body jewelry is available in different sizes (gauges) that are appropriate for certain piercings.

Body jewelry should always be made of 14-karat gold or surgical steel. Other metals that are frequently used for jewelry making, including sterling silver, should never be inserted in a fresh piercing. These metals do not promote healing, and they may even cause an infection.

It is also possible for a person to have an allergic reaction, in the form of a rash or an infection, to 14-karat gold or surgical steel. If this is the case, your body is very sensitive to foreign objects and is not well suited to piercing. If you are aware of having any allergies to metal, such as nickel, it is probably best to avoid piercing.

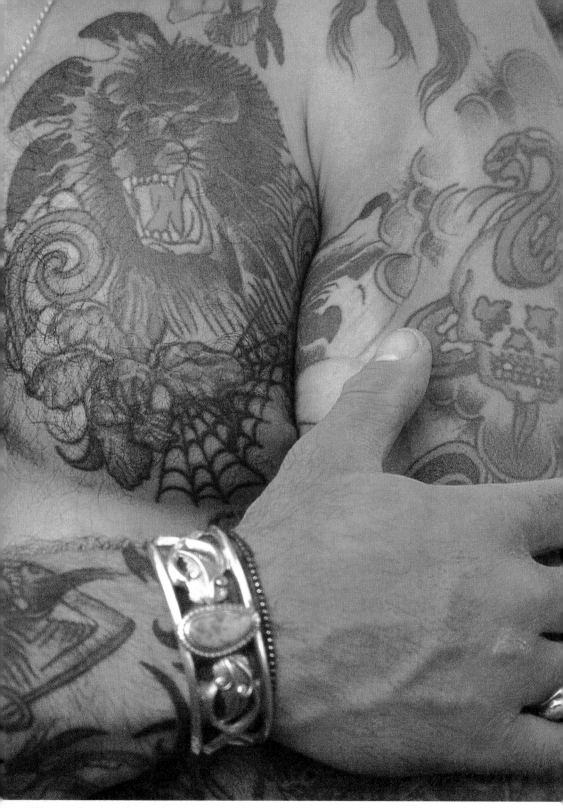

Many places of employment find visible tattoos or piercings unacceptable. Once you have a large tattoo, you are forced to deal with those types of limitations.

Chapter 3

A Lifetime Commitment

The decision to have a tattoo or body piercing is one that will be with you for the rest of your life, since tattoos and piercings are permanent, leaving at least a scar or hole. Peoples' tastes often change with time. Fashion also changes. What happens if you get tired of your tattoo or piercing? What if tattoos and piercings become a fashion no-no ten years down the road?

Another consideration is that body modifications such as tattoos and piercings are not acceptable in certain situations. In the workplace, for instance, they are perceived as unprofessional by most people. What can you do if you become tired of having other people judge you to be irresponsible or unprofessional because of your alternative fashion statement? It is useful to think about where you want to be in the future before you decide to receive a tattoo or piercing, because

these are permanent procedures that can never be fully undone.

Removing Piercings

Many people wrongly believe that if you remove the jewelry from a piercing, the opening will heal and close. This is untrue. Once properly healed, a piercing is permanent and, jewelry or no jewelry, you have a hole in your body. Facial and navel piercings tend to look unattractive without jewelry in them. While you can elect to stop wearing jewelry if you grow tired of your piercing, you will still have to live with a visible hole in your body.

Sometimes a plastic surgeon can perform microsurgery to remove the original pierced tissue and, using an ultrafine suture, close the new wound. Plastic surgery can be quite expensive, however.

Removing Tattoos

Tattoos can be even more problematic to deal with if you get tired of them. There are two options for someone who wishes to part with a tattoo. The first option is to have it covered with another tattoo. This is painful and extremely expensive. Most tattoo artists charge very high fees to cover one tattoo with another.

The other option is laser surgery. A doctor uses a laser to remove the colors or pigments from the tattoo. Unfortunately, laser surgery does not always work as effectively as some people imagine. The laser removes the ink by breaking it down into very

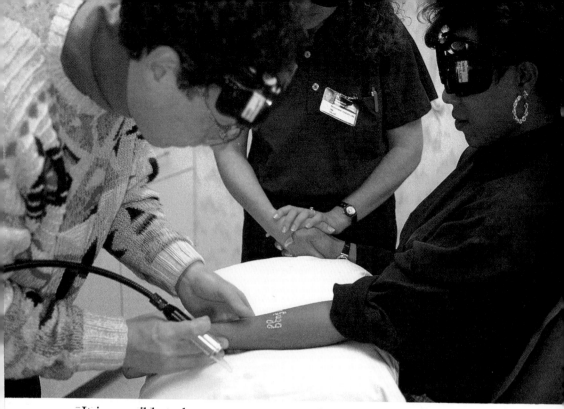

It is possible to have a tattoo removed, as this former gang member is doing, but it is expensive, painful, and leaves a permanent scar.

small particles. The ink is then absorbed into your body, where it remains for the rest of your life.

Laser surgery may leave a flesh-colored scar behind that resembles the tattoo that was removed. It may also be ineffective in removing certain kinds of inks, leaving clients with a faded tattoo. Green and yellow inks are the most difficult to remove, whereas blue, black, and red inks usually respond well to laser surgery. During the last decade, improvements in laser surgery have made the procedure safer and more effective.

Laser surgery is often very expensive. Removal usually requires four to ten treatments, which are spaced at least one month apart to allow the site to heal. The

cost to remove one square inch of tattoo ranges from $500 to $1,000. Also, tattoo removal treatments are not covered by most health insurance policies. Despite the cost, there is an ever-rising number of people who are having their tattoos removed. They want to get rid of their tattoos so badly that, to them, the extremely high cost is justified.

At 16, Lynn was initiated into a gang. As part of her initiation, she was given a jailhouse tattoo, that is, a homemade tattoo. Another gang member cut the gang's emblem on her hand with a razor blade and then rubbed red ink into the wound. Lynn's tattoo identified her as a member of her gang.

As time went on, Lynn realized that gang life was not for her. Her buddies were heavily into drugs and had even participated in a few carjackings. Within a year, Lynn decided to leave the gang. It wasn't easy, but she knew it was for the best.

When she graduated from high school, Lynn tried to find a job. She went on interviews, but just couldn't land a job. She began to think that her tattoo had something to do with her inability to find employment. After all, she had earned good grades in school. Desperate, Lynn asked her parents what she should do.

Lynn was lucky. Her parents offered to pay the high fee to have her tattoo removed by laser surgery. A month after the surgery, Lynn started a new job as a receptionist. She is very happy that she finally got her life together. Lynn's only regret is that she ever became associated with the gang. The scar in the shape of the gang's emblem serves as a constant reminder of a very unhappy time in her life.

Tattoo Removal for Former Gang Members

Tattoos are part of gang life. Jailhouse tattoos may be performed as part of a gang's initiation rite. Gang members also use tattoos to show off things such as how many people they have shot or killed or how many years they have spent in jail.

Former gang members may have trouble finding a job because of their identifying tattoos. Employers are

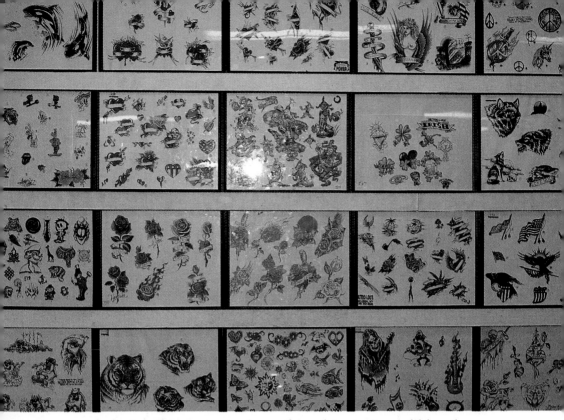

A design that you may have thought was incredible when you were 16 may not be as appealing when you are 25.

often reluctant to hire former gang members. Thousands of teens feel that they have limited their opportunities by getting gang tattoos.

Some U.S. states sponsor programs that pay for the removal of tattoos of former gang members so that they can have a second chance in life. However, former gang members usually have to follow certain rules to be selected by the programs. They must first prove their dedication to starting a new life and leaving violence behind.

Many people change their minds about having a tattoo. Think carefully about whether you want to make a fashion statement that could cause you a lot of aggravation later in life.

Chapter 4

What You Should Know

*J*oshua is a 17-year-old who lives with his mother; his father died when Joshua was very young. Joshua is Jewish. An only child, he has always been very close to his mother and his four grandparents. His family means a great deal to him.

Joshua got a tattoo last year. He made the big decision to have a Star of David tattooed on his back. He always liked the way tattoos looked, and he thought this would be a great way to express his religious pride. He also thought that his family would be pleased with his devotion to his religion.

When Joshua showed his mother his new tattoo, he received the shock of his life. She wept as she told him that the tattoo could make it hard for him to receive a traditional Jewish burial when he died. Joshua couldn't believe his ears. He hadn't known that tattoos were a violation of his religion. The thought that he could not receive the same type of

33

A parent or another trusted adult may be a good person with whom to discuss your interest in getting a tattoo or body piercing.

burial that his father had received filled Joshua with grief. He was beside himself.

Tattoos and piercings are considered taboo or unacceptable by many religions. Like members of the Jewish faith, members of certain Christian denominations cannot be tattooed or pierced. The Bible says, "You shall not make any cuttings in your flesh . . . or tattoo any marks upon you" (Leviticus 19:28). If your religion forbids these activities and you wish to remain in good standing, you cannot get a tattoo or piercing. Ask at your place of worship if tattoos and piercings are permitted in your religion.

If you are thinking about having a tattoo or piercing, you must also find out if it is legal to do so where you live. Tattooing is illegal in some places, including Connecticut, Florida, Kansas, Massachusetts, Oklahoma, South Carolina, Vermont, and Albuquerque, New Mexico. Check with your state health department to find out if tattooing is legal in your community.

Regions that permit tattooing and body piercing may restrict these activities to persons 18 years of age or older. Some communities may allow tattooing of those under 18 only with the consent of a parent or guardian. In this case, your parent or guardian must go with you when you have the procedure performed, and both of you must bring some identification that proves your relationship.

You may want to consult with your place of worship to find out whether tattoos are acceptable in your religion.

Again, contact the health department of your state to obtain information about such restrictions.

All of these laws exist to protect your health. Even if local laws permit you to get a tattoo or piercing, you may want to reconsider any plans you may have. The fact that so many health officials forbid these practices is strong evidence that they can put your health and your life in serious jeopardy.

Chapter 5

False Expectations

All too many teens make the decision to be tattooed or pierced based on misinformation. Others simply lack important knowledge about the procedures. They have false or unrealistic expectations of what their tattoo or piercing experience will be like. A majority of them come away disappointed or dissatisfied with the results.

By the time Craig was 14 years old, he knew that he wanted a tattoo. He called the health department in his state to find out if tattooing was legal in his community. It was. He discussed the possibility with his parents, who urged him to do some careful thinking about his decision. Craig realized what a big commitment he was considering; a tattoo would be with him for the rest of his life. He thought long and hard about it before he realized that there was no reason to be hasty; he would wait until he turned

16. By that time he would be more confident of whatever decision he made.

Craig spent the next two years gathering as much information as he could about tattooing. He found out that he did not need to be 18 to get a tattoo in his community. He talked with several of his peers who were tattooed. They all assured him that their experiences were fabulous. They said they had felt no pain at all during the procedure and were completely satisfied with the tattoo they had gotten. Craig felt reassured.

Next, Craig arranged to visit some of the local tattoo parlors. He wanted to see what the atmosphere was like in each one. He was looking for a clean environment. At each studio he looked for an autoclave to sterilize the needles.

Finally, Craig settled on a tattoo parlor that he liked. It was clean, they used brand-new needles on each client, and they did use an autoclave to sterilize the rest of the equipment. Craig was also crazy about the tattoo flash that appeared on the walls of this studio. One wild design particularly appealed to him. This was the tattoo he would get; it would cost $200.

On his 16th birthday, Craig returned to the tattoo parlor. He was excited and also a little nervous. Everyone else in the studio was much older than he was. He felt intimidated. It seemed as though he was in the waiting room forever.

At last, it was Craig's turn. He showed the tattoo

artist the design he had chosen. He wanted it
tattooed on his back with black ink. He sat down
and the tattoo artist got to work. First, he drew the
design on Craig's back with a pen. Craig watched in
the mirror. The design looked much bigger than Craig
had imagined it. He almost said that the drawing
was too big, but he hesitated. The tattoo artist was
very busy. He probably didn't have time to redraw a
design on some kid's back. Besides, Craig was sure
that he would adjust to the size of the tattoo.

Then the tattoo machine went on with a very loud
buzzing sound. Craig broke out in a sweat. When
the needle entered his skin, it hurt a lot. It felt as
though the tattoo artist was dragging the needle
across his back, ripping flesh as he went. There was
an awful odor that smelled like burning skin. It
made Craig feel nauseated.

The entire procedure took about two hours. Craig
was relieved when it was over. He was sure he
would have thrown up if the pain had lasted another
minute. The tattoo artist put a bandage over the
tattoo and told Craig to leave it on for 24 hours. He
also informed Craig that he could not go swimming
for one week, that he must not stay in the sun too
long, and that he must apply antibiotic ointment to
the tattoo several times a day.

Craig was free to go home and get acquainted
with his new back. When he removed the bandage
the next day, he was once again startled by the size
of the tattoo. It was definitely too big. He wished he
had said something to the tattoo artist. He was also

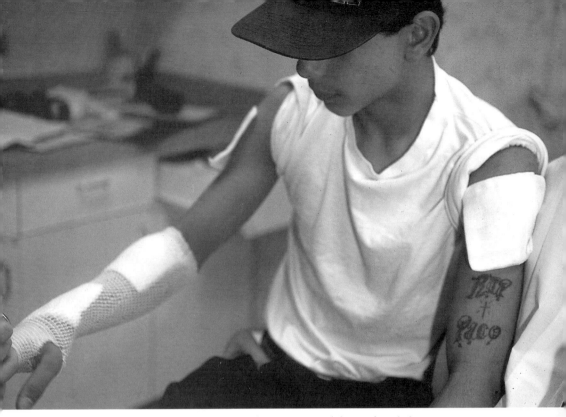

Most people don't realize the pain and length of time
involved in recovering from getting a tattoo.

*alarmed by the amount of blood that was on the
bandage. The tattoo itself was now one enormous
scab. It was really disgusting. Craig's back felt sore
and bruised. Over the next two weeks he was in pain
every time he showered.*

*About two months later, Craig's tattoo was
completely healed. It was still too large for his taste,
and the beautiful black ink had faded to a bluish
gray color. Craig was really unhappy with his tattoo.
It had cost a lot, it had hurt a lot, and now he was
stuck with it. The whole experience was a disaster.*

Many people who are planning to get a tattoo are
so excited that they neglect to think about what is

involved in the procedure. The act of tattooing breaks the skin. Do you remember the last time you got a shot at the doctor's office? It hurt. Getting a tattoo hurts just as much, only the pain lasts a lot longer.

Most simple tattoos take at least an hour to complete. Large or fancy tattoos take several hours. The pain lasts throughout the procedure. It is not uncommon for a person to throw up or even faint. A responsible tattoo artist only works for three or four hours at one visit. A second visit is usually scheduled after the first section has had time to heal. Limiting the length of a tattoo procedure reduces the risk of illness.

In rare but serious cases, some very sensitive people have gone into shock while getting a tattoo.

Care of a Tattoo

Caring for your tattoo as advised by your tattoo artist will reduce the possibility of infection. It will also minimize fading of the colors. Still, all tattoos fade considerably as time passes. Black ink fades to a bluish-gray. Other bright colors also become dull. This is normal.

Someone who is unhappy with a dull tattoo can arrange to have it touched up. More ink is applied to the tattoo, giving it a fresh appearance. But it is advisable to wait several years before having a tattoo touched up, and it should be done only a

few times. You can get ink poisoning by having ink constantly reapplied to one area of the body. Ink poisoning is rare but serious and requires medical attention.

Unfortunately, india ink is sometimes used on a tattoo. This type of ink is very black, and it does not fade. Many people find this appealing. But you should *never* be tattooed with india ink. India ink contains poison. It probably will not kill you, but it can make you extremely ill. It can also prevent you from having children or cause birth defects in the children you do have. The type of poison in india ink affects the genes that you will pass on to your children, and flawed genes are a major cause of birth defects.

Drawbacks of Piercing

Piercing has some of the same drawbacks as tattooing. It is intensely painful. It is also fairly expensive. The charge for a piercing and one piece of jewelry ranges from $60 to $100. A fresh piercing also requires a great deal of care to prevent infection. The piercing and the area around it must be kept clean at all times.

The average healing time for a tattoo is four to six weeks, but a piercing may take much longer. Nose piercings and some others take four to six weeks. Others, such as navel piercings, take four to six months. It should be noted that these

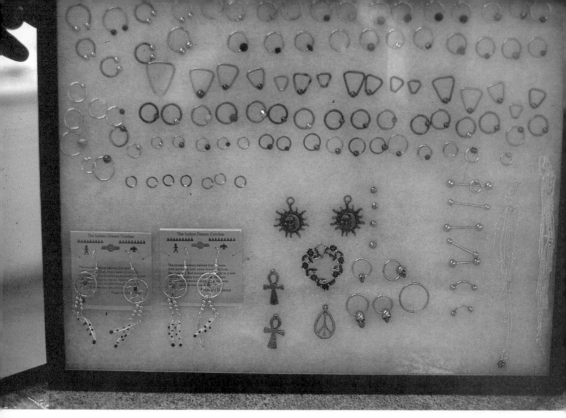

The price for a small piece of jewelry and a piercing can be up to $100 or more.

estimates are just averages. People heal at different rates.

Until a piercing heals, it will feel tender and sensitive. Once it has healed, the discomfort should disappear. If a piercing is constantly itchy despite its being kept clean and dry, or if it is red and sore or oozing pus, it is probably infected. If you are not healing at all, or if you have signs of an infection, call a doctor immediately.

For reasons unknown, some people's bodies are not suited to piercing. Their body literally rejects piercing, even if they have been careful to follow the after-care instructions. A severe infection develops, and the jewelry must be removed. The

piercing then heals and closes, leaving a scar. This process is known as growing out or healing out. Some types of body piercings tend to grow out more often than others. For example, 50 percent of all navel piercings grow out. It is also possible that your body will accept one type of piercing and reject another. Your nose piercing may last, but your tongue piercing may close.

Charrelle made an appointment to have her navel pierced. She was so excited that she gave little thought to what the procedure would be like. She just kept thinking about how beautiful a ring would look in her belly button.

When Charrelle arrived for her appointment, she was asked if she had eaten anything in the past four hours. She hadn't, so she was told to go and eat something before the piercing. The reason for this, they said, was that she would be less likely to faint if her stomach was full. Charrelle couldn't understand why anyone would expect her to faint. It wouldn't hurt, would it? They were going to use anesthetic or give her a painkiller. Weren't they?

Charrelle returned an hour later. She was led into a small, private room with a table of the sort that you would find in a doctor's examining room. She lay down on the table. The practitioner made two dots on her stomach, one just above her belly button and one just inside it. Charrelle asked if she would be given something to make her stomach numb.

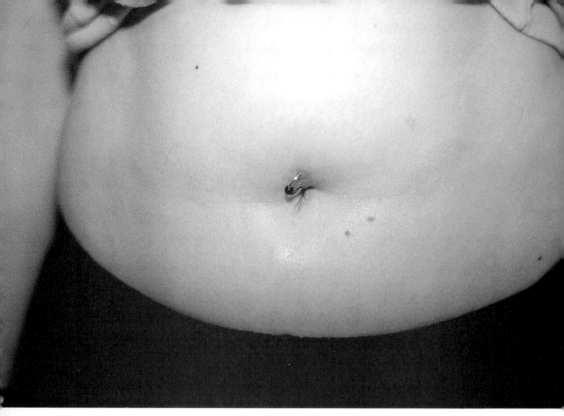

Even those whose bodies don't reject the jewelry in a navel piercing face several months of irritating infections until the wound heals. And once the wound heals, it may not look as great as you thought it would.

Samantha, the piercer, said that the law did not permit her to give painkillers or anesthetic. Such drugs can be administered only by a licensed medical practitioner. Charrelle got nervous; she hadn't expected to feel the pain of the piercing. She was brave, though, and she asked Samantha to continue with the procedure.

The initial pain was very intense, but it lasted only for a few minutes. This pain was replaced with soreness. For several weeks, Charrelle's stomach felt bruised. Even after that, her clothing irritated the piercing. A clear fluid kept accumulating around the piercing. Charrelle recognized this as a normal part

of the healing process that Samantha had told her so much about. It would take four to six months for her piercing to heal.

About two months into the healing process, Charrelle developed an infection. She treated it with antibacterial ointment, but this did not help. Worried, Charrelle made another appointment to see Samantha. Samantha informed Charrelle that her body was rejecting the piercing. There was nothing to do but remove the jewelry and let the piercing close.

Charrelle was left with an ugly scar on her stomach. She was also left with the feeling that she had been cheated. She had endured the pain. She had gone to the trouble of keeping the piercing clean and avoiding swimming pools. Yet she had nothing but a scar to show for her trouble.

Chapter 6

Preventing Infection

We have already mentioned that you can be infected with hepatitis, HIV, or another disease if you are tattooed or pierced with unsterilized equipment. You also know that an autoclave is used to sterilize tattooing and piercing equipment. If you decide, after considering all of the information, to have a piercing or tattoo, make certain that the equipment has been sterilized in an autoclave. You have the right to ask the person performing the procedure to use a new needle. A responsible practitioner will confirm the sterility of all equipment and will use a new needle.

Another thing that you can do to protect your health is to make sure that the person performing the procedure is wearing latex gloves. This protects you from infection by the practitioner and protects him or her from contracting any illness that you may have. Most tattooers and piercers routinely wear latex gloves whenever they perform

their work. If your practitioner does not put on gloves, do not be afraid to ask him to do so. Your health is at stake!

Once you have a new tattoo or piercing, there are a number of things you can do to prevent infection and promote healing. The professional who performs the procedure should go over these instructions with you. It is essential that you follow them.

Infections frequently occur even with proper care. Improperly caring for a new tattoo or piercing is asking for trouble. Even minor infections can spread quickly and become serious. Some infections such as gangrene can be life-threatening. If you develop an infection, seek medical attention immediately.

Avoiding Infection of a Tattoo

Tattooing makes your body vulnerable to infection. It is extremely important to keep a new tattoo bandaged for the first 24 hours. It is a fresh, open wound. Exposing a wound to the air means exposing it to limitless types of bacteria and other infection-causing agents. An infection in a new tattoo is serious. It risks your health.

An infection in a tattoo also risks your tattoo. It is almost certain to damage the appearance of your new skin design. It may leave a scar, or it may make the colors of your tattoo uneven.

After the bandage comes off, you must apply antibacterial ointment to the area several times a day. Bacitracin, Neosporin, and Micotracin are brands of over-the-counter antibacterial ointments that are frequently recommended for use on tattoos. Ointment should be applied at least three times daily for two or three weeks. Always wash your hands to rid them of infection-causing germs before you apply the ointment.

Almost immediately, your tattoo will scab, and then it will become extremely dry. It is important to keep it moist for the first month or two. The ointment will be enough to keep it well moisturized for the first two or three weeks. After that, you must moisturize it with skin lotion. Dermassage lotion is often recommended for this purpose. Once your tattoo scabs, it needs to be exposed to the air in order to heal properly. Never use Vaseline or other petroleum jelly; it will seal your tattoo from the air and prevent it from healing. Petroleum jelly can also trap germs under its seal and cause an infection.

Never pick or pull at the scabs on your tattoo. This will reopen the wound and leave you susceptible to an infection. Picking the scabs off can also cause permanent damage to the tattoo. On a new tattoo, the ink is very close to the surface of the skin. When you pick a scab, you pick the ink out of your skin. When the scabs heal, the skin on your tattoo will be dry and will peel.

Your efforts to keep your new tattoo or piercing clean and free of infection will limit your activities.

Do not peel the dry skin off of your tattoo. Let nature take care of that. It is possible to reopen the wound this way, once again exposing you to infection.

Do not go swimming for at least two weeks after getting a new tattoo. There are two reasons for this. First, most swimming facilities are public. Other people's germs may linger in the water and infect you. Second, swimming or soaking in water will dry out your tattoo and prolong the healing process. Do not soak in a sauna, steambath, or bathtub for two weeks. When you get out of the shower, gently pat your tattoo dry with a clean towel. Then apply antibacterial ointment or moisturizing lotion as appropriate.

Avoid exposing your tattoo to direct sunlight for two to four weeks. Sunlight will fade the colors.

Avoiding Infection of a Piercing

Like a tattoo, a piercing opens your body to infection. In addition, it involves the insertion of a foreign object into your skin, which your body may or may not accept. Infection may result. Consequently, your new piercing should be kept clean at all times. Never touch it with dirty hands. When you shower, wash the piercing with an antibacterial soap. Pat it dry when you get out of the shower. For the first few days, you may wish to apply an antibacterial ointment to the piercing.

Prolonged use of ointments is not advisable, however, because they tend to keep the air away from the pierced area.

Your piercing should be washed at least three times a day for as long as it takes to heal completely. If it is not possible to shower that often, cleanse the piercing with an antibacterial wash such as Betadine. some types of piercing require special care; ask your practitioner for care instructions. Never use alcohol or hydrogen peroxide to clean your piercing; they are too harsh, and they may prevent healing.

Soaking your piercing in a saltwater solution can speed the healing process. Remember, the time can range from four weeks to six months. Anything you can do to speed up the process is to your benefit.

Your flesh can heal onto the jewelry, which results in a painful and unattractive piercing. For that reason, you must turn the jewelry in your piercing at least three or four times a day. Wash your hands and then very gently turn the jewelry completely around five times. Also avoid swimming for two weeks after being pierced.

Other Problems with Piercings

People who get tongue piercings run the risk of damaging their teeth and gums. The spike or stud can crack or knock out teeth. Also, it can cause infections and abrasions in the delicate tissue of the mouth.

In addition, people who get piercings need to be careful to avoid "pull-through" injuries, which occur

when the jewelry gets stuck on an object and is
ripped from its hole. Pull-through injuries can cause
extremely serious infections and permanent damage.
They often require plastic surgery to be repaired.
One 12-year-old girl nearly lost her ear due to a
severe infection that developed after she caught her
earring on a blanket, tearing cartilage in the upper
part of her ear.

Caring for a piercing or tattoo requires patience
and effort. It may be many months before you can
show off your new decoration. If you want immedi-
ate results, if you're not very flexible about changing
your daily routine, or if you are forgetful about
things like flossing or cleaning your contact lenses,
you might want to reconsider before taking on the
responsibility of caring for a tattoo. You should also
be prepared for the possibility that your body may
reject your piercing or have an allergic reaction to
the inks of your tattoo. An allergic reaction can
occur even if you follow all the rules to prevent
infections and other complications.

There are many brands and styles of jewelry for non-pierced people.

Chapter 7

Alternatives to Tattooing and Piercing

Since tattoos and body piercings have become so fashionable, several products have become available that allow you to participate in the fad without actually getting a tattoo or a piercing.

Temporary tattoos, much like the ones you may have bought as a child, but greatly improved, have become extremely popular. A wide assortment of tattoo flash is available in temporary form. The colors of temporary tattoos have been greatly improved and are bright and vibrant. Temporary tattoos can be purchased in record stores and magazine shops everywhere. They are an inexpensive, safe alternative to permanent tattoos.

Recently, the designer Jean-Paul Gaultier launched a line of clothing featuring tattoo designs. The snugly fitting garments are covered with all sorts of tattoo flash. Some are literally

covered with tattoos; others have only a few.

Many other popular designers, such as Alexander McQueen, John Galliano, and Dolce & Gabbana, have also used fabric tattoos in their recent collections and adorned runway models with temporary tattoos. Although their original designs are very expensive, more moderate, tattoo-inspired collections are sure to follow.

Body jewelry for non-pierced people is becoming extremely popular. Clip-on earrings, nose rings, and navel rings are widely available. Magnetic studs— which look like a piercing, but are held together by the attraction of two magnets—are also available for the ears, lips, nose, or tongue. This jewelry costs less than a piercing, and it gives you the opportunity to be part of the piercing trend without having to make any holes in your body and risk infection or scarring.

The current fascination with tattoos and body piercing has caused many people to consider getting a tattoo or piercing. It is important to think about all the possible consequences before actually getting one: the possibility of contracting a blood-borne disease, such as AIDS; the possibility of infection; the possibility that your body will reject a piercing, leaving a hole or scar; the possibility that, when fashion changes, you may wish to get rid of a piercing or tattoo; the possibility that a piercing or tattoo will negatively affect your future; and the fact that removing a tattoo or piercing is expensive.

If, after carefully considering all of the information, you do decide to have a body piercing or a tattoo

done, do so with care—for the sake of your health.

If you decide that piercing and tattooing are not for you, there are many fashion alternatives available that do not involve the puncturing of your skin and the permanent marking of your body.

It is your body and your decision. It is up to you to take care of it wisely.

Glossary

autoclave Machine that sterilizes tattoo,
 piercing, and surgical equipment by using steam
 pressure.
dermatologist Doctor who specializes in skin
 care.
flash Selection of tattoo designs that hang on the
 walls of tattoo parlors.
gangrene The death of soft tissues due to loss of
 blood supply.
hepatitis Acute viral disease involving
 inflammation of the liver.
hygiene Cleanliness; practices to conserve health.
jailhouse tattoo Tattoo that is handmade and
 homemade.
rite of passage Ceremony that celebrates an
 important event in a person's life.
septum The part of the nose that separates the
 two nostrils.

Where to Go for Help

For more information on tattooing and body piercing contact the following organizations:

Alliance of Professional Tattooists
7477 Baltimore-Annapolis Boulevard
Suite 205
Glen Burnie, MD 21061
(410) 768-1963

American Society for Dermatologic Surgery (ASDS)
930 North Meacham
Schaumburg, IL 60173
(800) 441-2737
The ASDS also publishes fact sheets on dermatologic surgery for tattoo removal and microsurgery.

Association of Professional Piercers
519 Castro Street
Box 120
San Francisco, CA 94114

In the United States, your state health department is another great resource for information on the dangers of tattooing and body piercing. Look in the White Pages of your telephone book for the address and telephone number.

In Canada, you can contact **Health and Welfare Canada** at (613) 957-2991 for information.

See a dermatologist if you have questions about the safety of tattooing or body piercing or if you have a problem with a tattoo or piercing.

See a cosmetic surgeon if you have questions about removing a tattoo or piercing.

For Further Reading

Hammerslough, Jane. *Everything You Need to Know About Skin Care.* New York: The Rosen Publishing Group, 1994.

Kaplan, Leslie S. *Coping with Peer Pressure.* Rev. ed. New York: The Rosen Publishing Group, 1996.

Krakow, Amy. *The Total Tattoo Book.* New York: Warner Books, 1994.

Stine, Megan. *Tattoo Mania: The Newest Craze in Wearable Art.* New York: Bantam, 1993.

Taylor, Barbara. *Everything You Need to Know about AIDS.* Rev. ed. New York: The Rosen Publishing Group, 1995.

Wirths, Claudine. *Choosing Is Confusing: How to Make Good Choices, Not Bad Guesses.* Palo Alto, Calif.: CPP Books, 1994.

Index

About the Author
Laura Reybold is a freelance writer who lives and works in New York.

Photo Credits
Cover photo, p. 20 by Michael Brandt; photo on p. 2 ©1989 Tom
McGovern/Impact Visuals; p. 10 © 1992 Andrew Lichtenstern/Impact
Visuals; p. 14 © Donna DeCesare/Impact Visuals; p. 26 © Ed Peters/Impact
Visuals; p. 36 by Kathleen McClancy; pp. 29, 41 © 1995 C. Takagi/Impact
Visuals; all other photos by Kim Sonsky.